Street

BOTTOM DOG PRESS

Street

Poems by Jim Daniels

Photographs by Charlee Brodsky

Working Lives Series
Bottom Dog Press
Huron, Ohio

ISBN 0–933087–93–4

Bottom Dog Press
P. O. Box 425
Huron, Ohio 44839
http://members.aol.com/lsmithdog/bottomdog
Contact Lsmithdog@aol.com

For my family — Jim Daniels

*For my father George Brodsky and my husband Mark Kamlet,
the two men in my life — Charlee Brodsky*

Acknowledgments

We thank the subjects of these photos for their trust. We also thank Carnegie Mellon University's Berkman Fund and the Ohio State Arts Council for providing the funds to make this project a book. And, we are indebted to Larry Smith, publisher of Bottom Dog Press, for putting our work into people's hands.

The photographs in this collection were made in Pittsburgh neighborhoods during the 1980s. The poems were written in 2004. These poems are fictional and are not meant to represent the actual lives of the subjects of these photographs.

The following poems and accompanying photographs have previously appeared in these publications:

The Connecticut Review:
"Bad," "Parking Chair," "Texture."

Heartlands:
"Queen Isaly and Her Three Bags,"
"Boy with Comb and Blur,"
"Okay, But Make It Quick,"
"Seeing a Dog About a Man."

The Indiana Review:
"One Key," "Overtaken by Bulldog."

Michigan Quarterly Review:
"Haloes."

Slipstream:
"American Young, American Darling."

Tampa Review:
"Breeze," "Ash," "Glow," "Fringe."

Witness:
"Pure Imagined Moon," "Chaos Theory,"
"Pudgy," "Girl with Giant Purse,"
"The Art of Letting It All Hang Out."

The Worcester Review:
"The Human Cigarette,"
"Two Drainpipes, One Hose,"
"You Want to See Your Self."

The Yalobusha Review:
"Bad News," "Faith."

Introduction

The urban landscape is a maze of
bricks, barriers, boundaries, noise,
smells, textures, and lives. Walking
the streets, there are many paths to
take. As a poet and a photographer,
we navigate towards a visual and
emotional center in the images we
record and create. The photographic
eye and the poetic eye have much
in common, and much that make
each distinct. We create words with
pictures, and pictures with words,
and, ultimately, shape our creations
into an experience of place.

— Jim Daniels and Charlee Brodsky

Street

The Art of Letting It All Hang Out 11

The Invisibility of Doors 39

Stillness and Sway 65

The Art of Letting It All Hang Out

This and That 12

One Key 14

Faith 16

Chaos Theory 18

The Art of Letting It All Hang Out 20

Pure Imagined Moon 22

Strangulation 24

Buckle 26

Bad News 28

Madonna and Child 30

Pudgy 32

Vertical and Horizontal 34

Girl with Giant Purse 36

This and That

cleavage and curly hair

polka dots and frills

jelly roll and tap dance

turnpike closer and fender bender

bulldozer and lightbulb changer

clout and pout

spit shine and set table

vibrato and glissando

brass and strings

hip shake and deer prance

brawn and yawn

planet and star

elbow to hip

elbow to head

pieced together, whole

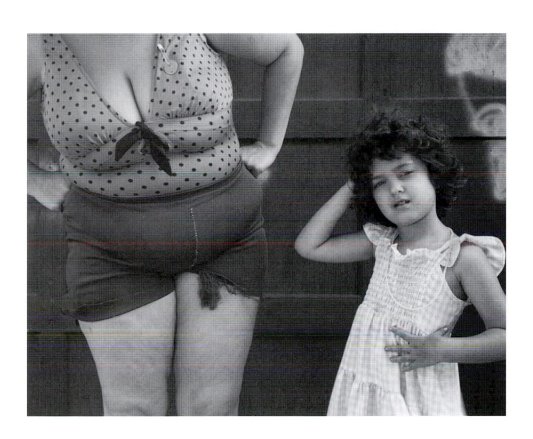

One Key

one river, one door.
ridged fingers curled
around one cane,
and one imaginary cane.

ignore the curtains,
look at the man behind them.

landscape of buttons,
layers of clutched cloth.
buttons of flesh. spelunk
in the warm darkness.
clutch at the heart.

•

one mouth. imaginary
teeth. old potato
wrinkling in the cellar

dirty napkin
of survival. spittle
and clipped nails

and memory and the wink
of an opened zipper.

say what you will,
with one key
you are never lost.

•

cane slant
like a tent pole
like a sunflower
tilting toward light
like a whipped flagpole
like a litter stick
like a forgotten project
like a fishing rod
with lost bait
like a thermometer
held tightly between lip
like a morning erection
like an uncertain umbre la
like a pen, tilted, ready.

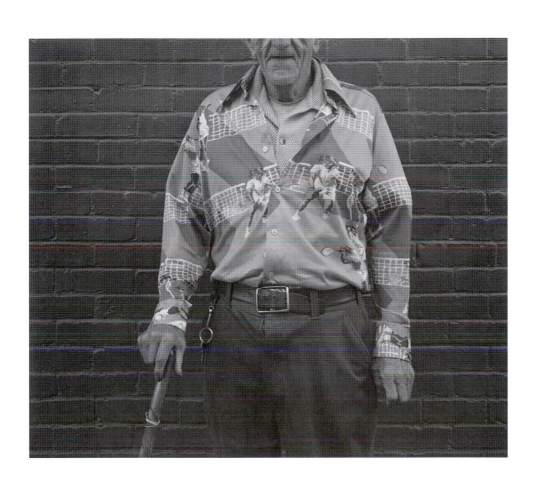

Faith

If God hung a sheet out on the line to dry
it would look like this.

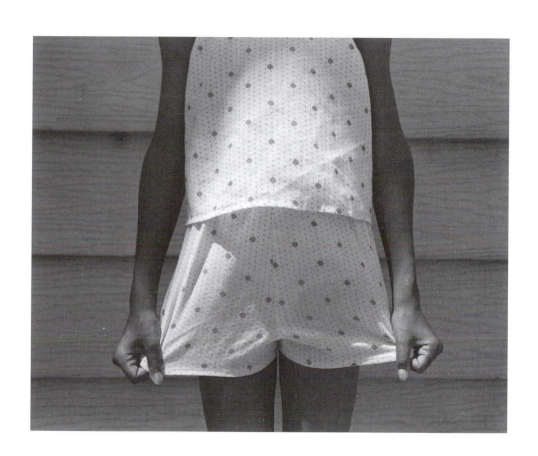

Chaos Theory

If the butterfly on this shirt
lifted off the fabric

it'd fuck every butterfly
within a mile in the next
fifteen minutes.

Something like that.
You'd better believe it.

Studs for a stud. That's
cancer growing under
his chin. Bullshit
growing above his lip.

Don't fuck with the butterfly,
man. Yeah. He's fattening

it up. Tough mother-fucking
butterfly. Its wings flutter

and all the bricks
come tumbling down.

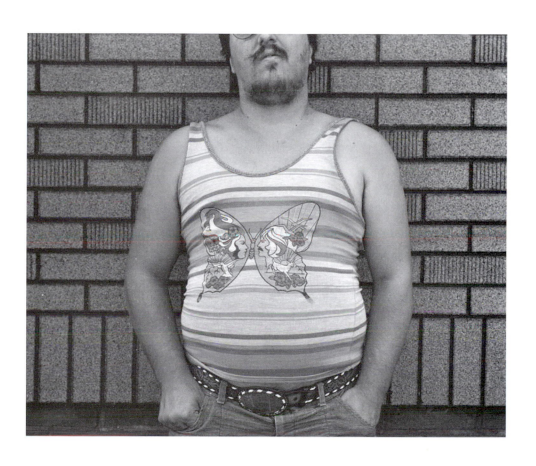

The Art of Letting It All Hang Out

she's a soft puzzle of bulging
pieces, the layers of a blue-
collar parfait. She spells delite
d-e-l-i-t-e and you better damn
well spell it the same way.

Anyone allowed to grab a hand-
ful has passed through the picnic
of transubstantiated hot sausage.
when it's time to pass go
she'll be the one saying so.

the lord is my lite and the simple
knot is my faith. Me, I'm interested
in the dark shadow between breast
and chest. I think I slept there once.

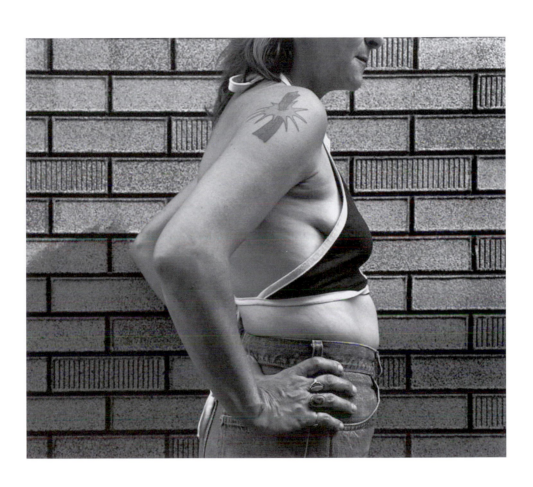

Pure Imagined Moon

One clean white button.
Empty pockets. Hunger

beneath it. The language of my sleeve
is all I have forgotten in this life

or all I can remember. The blotted
notes of my mother's sweet song.

For you see I am unmarried
and I believe like the nuns.

I am a human letter Y,
the muted cheer in the distance

for some hopeless team. My arms
hold a piece of the divine.

All the world needs is one white button
and one umbrella. Silly, I suppose,

but my pockets are sewn shut.

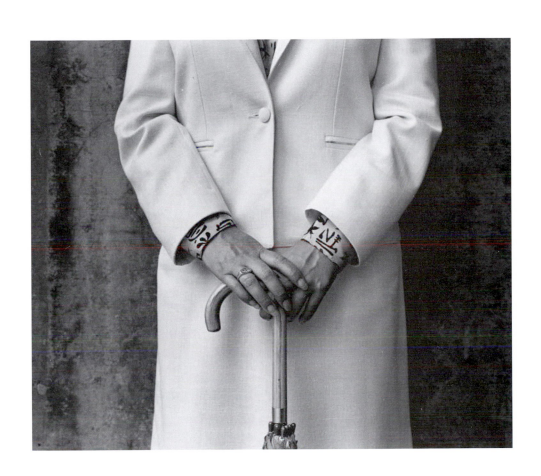

Strangulation

the flowers are poppies.
shoot up a syringe full
of that, you'd be talking
bad trip. the art
of deception. her breasts
are hand grenades. her
hands venomous snakes.
her belt laced with barbed
wire.
 or maybe she's just
somebody's grandma just
got her hair done and ain't
she cute?
 the country's got
its flag shades on and she's
Betsy Fucking Ross with her
Singer Sewing Machine taking
bucks on the side for product
placement.
 America needs
more political interludes
and fewer bake sales. more
Russian Roulette and less
Bingo.
 what do you think,
Grandma? aw, c'mon, don't
kick my ass just cuz I see
yer evil twin trying to borrow
that necklace.

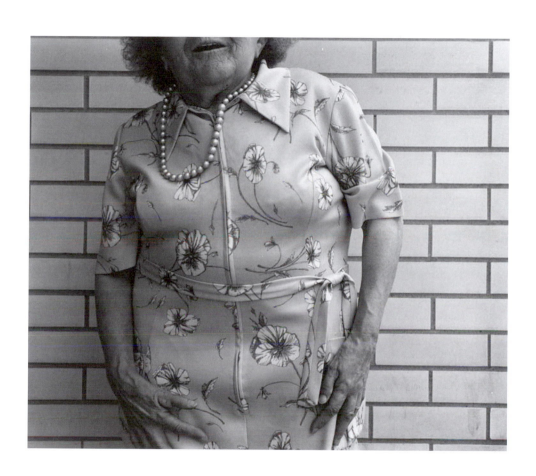

Buckle

To bend, warp, or crumple under pressure or heat.
To collapse. To surrender to another's authority; yield.

Gold pen: twenty-five years.
I clip it on. A joke, really.
What am I going to write down?
I sign the back of my checks with it.
A little piece of the boss
to stick myself with. A piece
of what I sold myself for.
What's not here is a gold ring.
What's here is not a gold ring.
My wallet next to my heart.
Nobody stealing it. The buckle
shines, but it's not gold. It
doesn't need to shine. It needs
to hold up. It needs to last.

Even this pen is hollow.
Even this pen bleeds.

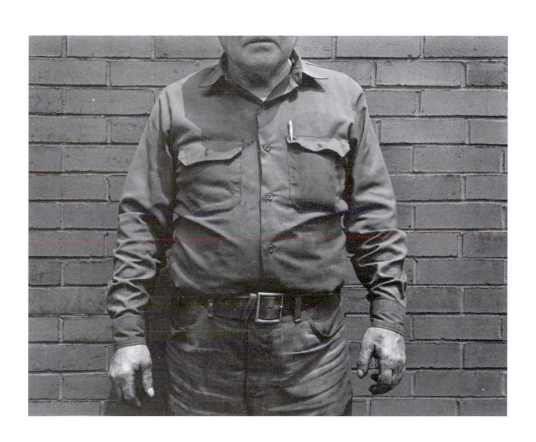

Bad News

Sight is a funny thing.
It's like a bad haircut.
I hate bad haircuts.
Take these glasses, for example.
We're all going to die.
Even you know that.
I once played in a rock group
called the Human Beans.
Nobody ever believes that.
You hate me. I'm trained
to recognize hate. To be hated.
I know you'll write me
a check and be *shocked!* at the amount.
The suit's nice. The tie—eh—
time for some new ties. My lips
like each other. Not everyone
can say that. You don't even wear
glasses and you're feeling
the temple pieces pressing into your head.
Every time you make a mistake
you get a little dent in the side of your skull.
I've done research on this. Touching
a skull is like an orgasm. Of course,
everything's like an orgasm.
You can touch the hem of my garment.
My right hand is always blurry.
I had to practice for years to get that
right. Nothing comes easy. They call me
the Human Streetcleaner.
They call you a sucker,
am I right?

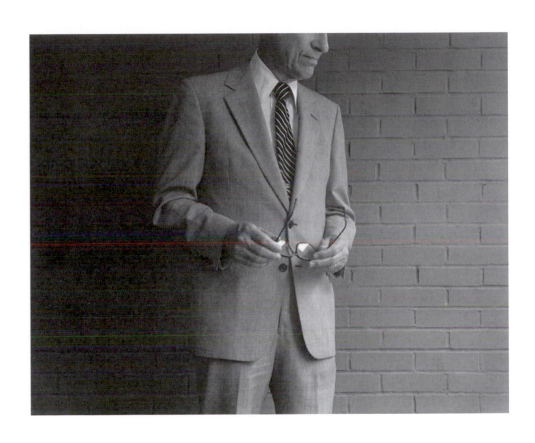

Madonna with Child

I undo the thick buttons
with a twist and a sigh.
The Lord is my savior.
Then something about *want*.

Everything soft between us.
The round world in my hands,
the city's crooked silence
melted into peace. Here.
Now. I am a shield
against all stones, all hardness.

I will feed the child.
I will put flowers
at the edge of everything.

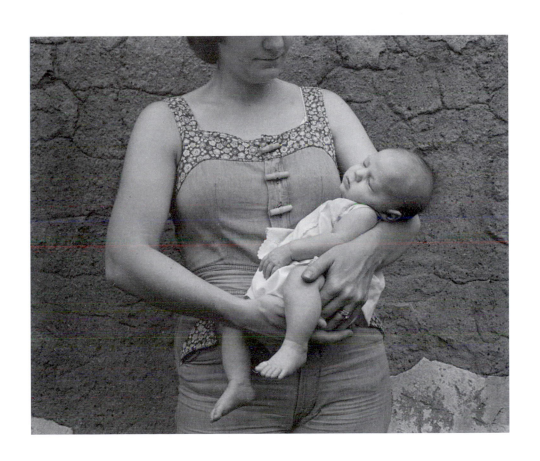

Pudgy

enough to still be kissing his medal
for luck. Baby fat. He could go either way.

Not heavy enough to be jolly fat.
Not thin enough to run with the ball.

He's not sure what *either way* means
or even imagines he has a choice.

His voice cracks agains the bricks.
He might be shrieking with delight

or fear. Somebody wants him to cut
the grass or clean his room. Maybe

he's got an answer for everything.
Maybe it's *oooooohhh*.

He could be holding in his gut,
his underwear pinching just a little.

Maybe the striped shorts make him faster.
Maybe his father will get him a job

with the city. Maybe someone
imagines he might become a priest.

For all we know he could have an erection.
Biting his lip, swallowing.

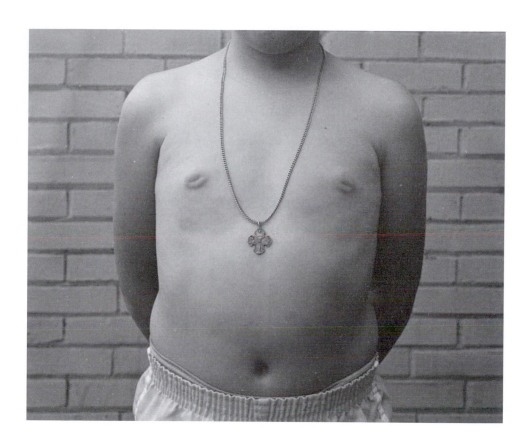

Vertical and Horizontal

If she was a tree trunk.

If the moon wore clothes.

If the wrinkle beneath the breast pocket.

If each spot was a love bite.

If the world never wavered.

If each loose thread was snipped.

If the handkerchief dabbed tears

and the cane whacked insolent knuckles.

If the shoulder slope led to a soft landing.

If the pocket contained folded cash.

If the crook of the elbows dampened

with someone held there.

If the stain of the neck was explained.

If the pavement did not buckle.

If there was a destination.

If the belt held something back.

If it ran through the loops.

If it was tied with a bow.

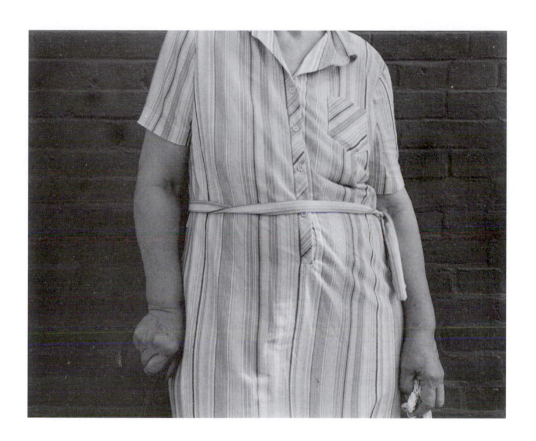

Girl With Giant Purse

I bet there's Chiclets in there
and Chapstick and Kleenex
and a house key and Lifesavers
and a compact and a change
purse. I'm 46 and just realized
my grandmother never drove
a car. For this is her purse.
She has left it on the bus.
This girl is returning it
and hoping for some reward.
My grandmother will fish
through the plastic and hand her
a dime and call her dearie.

•

She is the mother of the world
and the purse is the moon.

•

The purse holds her first
big sadness, heavier
than imagined.

•

She is a cloud's dream
and the smell of concrete
after rain.

•

The sound of the purse opening
a small bullet exploding
the cat out of the bag.

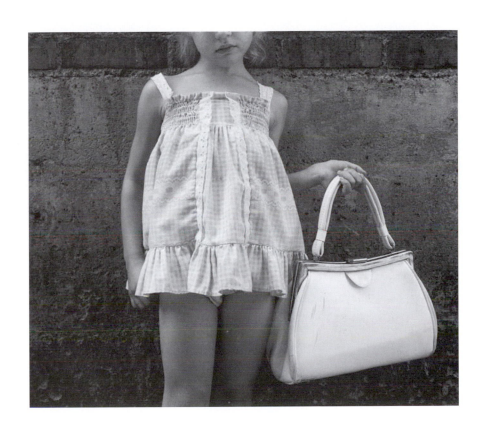

The Invisibility of Doors

Texture 40

American Young, American Darling 42

Queen Isaly and Her Three Bags 44

The Human Cigarette 46

Parking Chair 48

Bad 50

You Want to See Yourself 52

Two Drainpipes, One Hose 54

Two Boys with Iced Tea 56

Seeing a Dog About a Man 58

Okay, But Make It Quick 60

Boy With Comb and Blur 62

Texture

The wise ponderous face
of an ancient turtle.

Textures of strength
earned, grace deceptive.

A regal rhino
buying bargain clothes

and hand-labeled merchandise.
Beneath her head scarf

the warm glow
of a loving yet chemical smell.

Strong enough to be a human
playground apparatus and cook dinner

at the same time.
The line around her neck collects salt.

Someone still kisses her there.
Feel the breeze in her skirt.

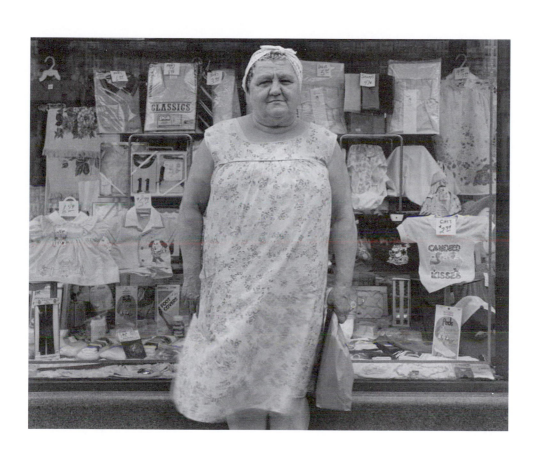

American Young, American Darling

Dirt on her sneakers
is the dirt on his sneakers.

The pure heart attack of his ticking belly
is the rock of her stoop.

Who taught her that hard stare?
See how her hand says this is mine

and do not step closer?

•

The short arms, the flecked and speckled
white flesh, one chain dripping

like a leash or rosary, the other
a constant tug on the sleeve.

•

American Young, who combed your hair
this morning, and who will ask you
to put out what fires?

Your father stands on the new cement
yet even now he begins to sink.

Whatever news he carries
in his back pocket
is nothing you want to hear.

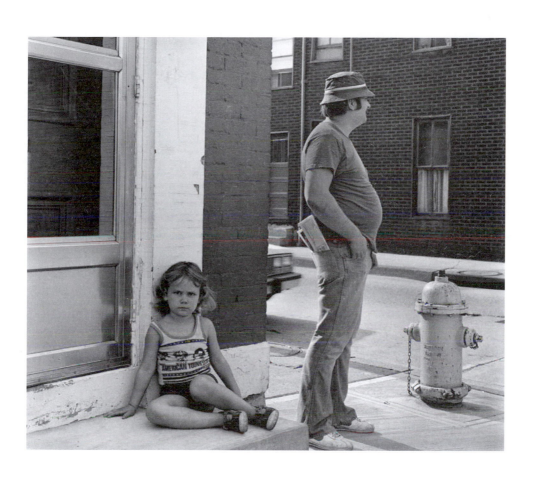

Queen Isaly and Her Three Bags

is not in love with Mr. Juicy.
No Orange Whirl for her.

The quaint old-fashioned streetlight
put in to save the business district

as if it were that easy to kick the mall's ass
reflects the aura of her fall.

No Mr. Juicy at the Mall.

The man on the bus stop bench
is no relation and every relation.

The world is a fragment and a shadow.
One pause and one cheap tear.

A drop of Windex sliding blue
down a display counter.

The crackle of a paper bag
the pure white purse.

She can hold at least three more bags
of various sizes, and she might.

She has parted a few seas and may part
a few more, or bulldoze them into oblivion.

I am falling in love with her white wrist
where her watch once recently told her

what she did not need to know.

No No No is supposed to equal yes.
The world's symetry is a root beer float

and the world's sadness is the shadow
of someone else's bag.

At every turning point in my life
she has stood in front of the door.

She is disappointed in me.
How I nudged her aside and entered.

How I dropped my pennies
and didn't look back.

Mr. Juicy, come back!

The square lights of heaven
the sidewalks of fluorescent dreams.

Every ceiling is false, she told me.

I don't expect you to understand
sitting across the street.

The bus rattles with routine.
Stacked jars of disappointment.

I leap from lit square to lit square.
Dance with me, I ask her every time.

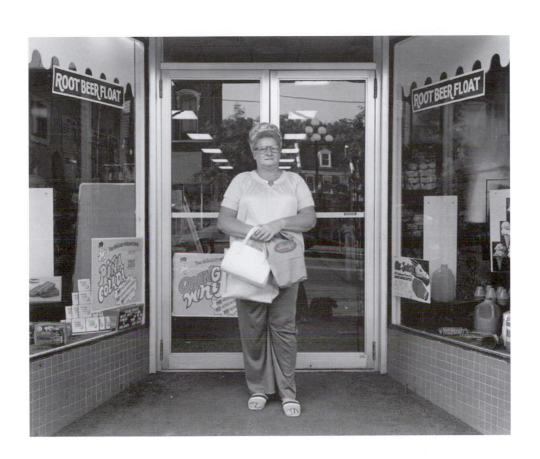

The Human Cigarette

He's got four minutes left
the bulge in his breast pocket
will explode, the black
of his clothes will imbed itself
beneath the ribs, the safety pin
holding his navel together
will pop, the stick in his hand
will lose its prop, the veins
in his forearm will emerge
to loop around his neck,
the creases in his cheek
will ooze poison, or maybe
it's four years. Got a light?
The fuse of his eyes.

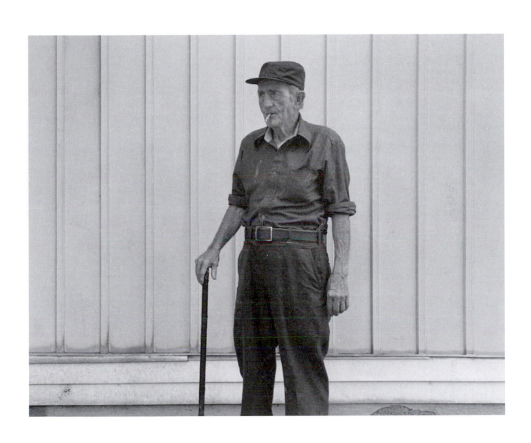

Parking Chair

the nice one's for him
and his fat ass
oh I don't mind

sitting on the steps
seems more neighborly
to me. The other's

our parking chair
used to be in my ma's
kitchen, yeah, cigarette

burns through the plastic
seat, long gone, like her.
1920—he bought those

numbers at the hardware.
Took him all day to get them
even. Yet he don't mind

the ugly chair.
He's a lot like the dog here,
faithful, in his own way.

Somebody parks in his spot,
ha, that'll set him off.
And I'd like to see it.

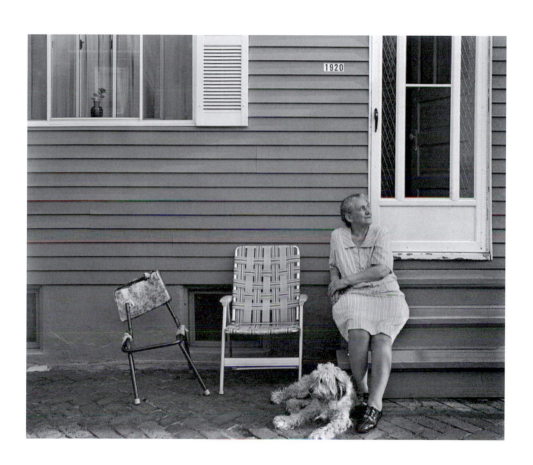

Bad

Two bolts — all that holds
the stop sign on

one monkey wrench
and she's on her way

onto the dusty path
down by the stinky river

scrub trees near the water
enough to hide in

next thing her name's in chalk:
Deb/Deb/Bad

she smudged it out.
It's back again. she's waiting

for she knows who
and for now

she's holding on.

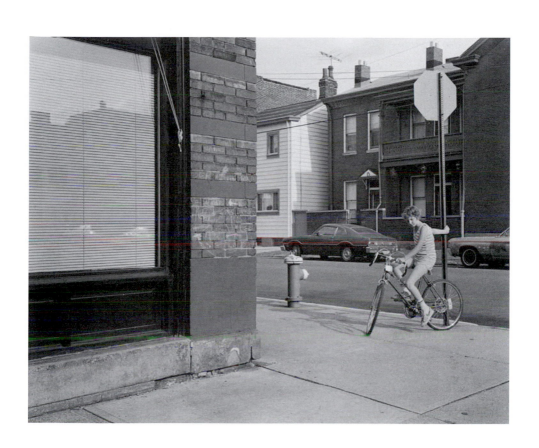

You Want To See Yourself

you look in your windows:
two things — your reflection
and your stuff. I'm clean,
and my stuff is clean. Hey
I'm talking to you. My life —
it's me, these sunglassses
and flowers, these sneakers,
this railing and these steps.
This fist, this rag.
It's me and my shadow,
you understand? We don't take
no shit, neither of us.

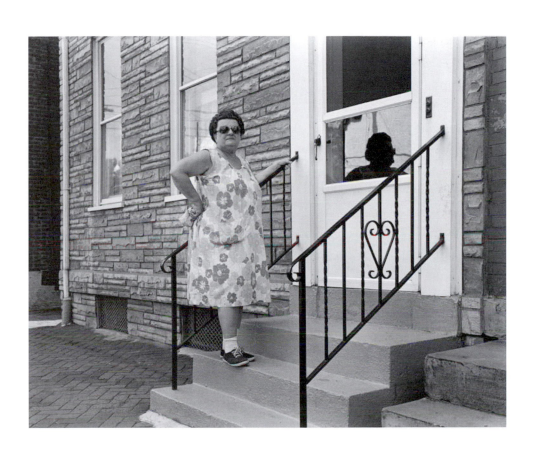

Two Drainpipes, One Hose

take them off to clean them right
rag and a hose, rag and a hose
on your knees, wet
ain't no shame in it
you take your time, spray
and wipe, you scrub them clean
somebody maybe steal them
they look so nice and shiny
but hey

just look at my drainpipe
and his drainpipe
that's all you gotta do
I mean, that's the whole story
right there

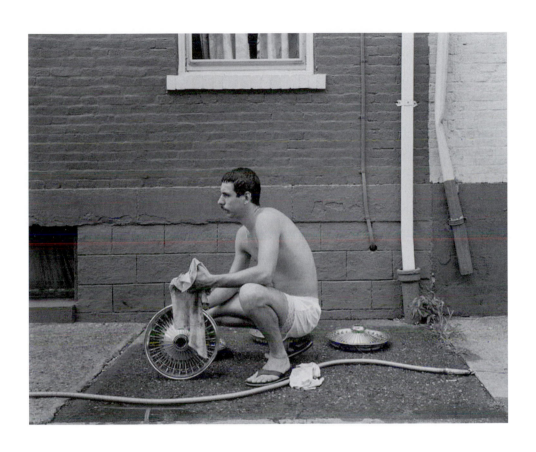

Two Boys with Iced Tea

the trinity of dust gravel weeds
two boys in pure angelic robes

the sacrament of a shared carton
sweet throats eagerly swallowing sin

•

tube socks and sneakers
vs. stirrups and cleats

one father a foreman
the other on the line

•

teammates on the Generics
waiting for the Name Brands

getting some shade while they can
figuring out what they'll be sorry for

•

the dust of eroded toxic paint
the world pressing against their heads

one crack in the wall
ten fingers

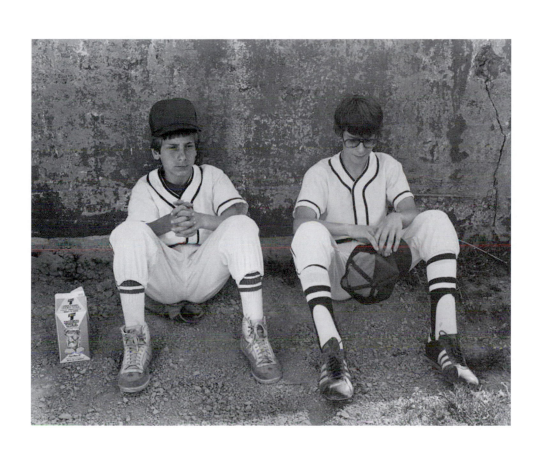

Seeing a Dog About a Man

The dog will outlive the man
and be given to a young couple
with two children who imagine
it's just what they need.

When the sidewalk cracks
it's just the beginning.

He never choked the leash
and he's proud of it. You're not
going to see him in white socks
at this late date.

The world's full of jokes about leashes
but none of them are funny. Metal
and leather, what's funny about that?

Yank, around the neck.
Yank, around the neck.
Somebody hanging from a light fixture
next to a kitchen chair.
What's funny about that?

We could be at the bottom of the sea
here among the anemone and random shells,
blind fish and dead telephones.

He waits at the white gate like a statue
the dog might pee on if so inclined.
Soon enough, they will call his name
the door will rise and disappear
into the sky

and the dog will wander away
chain dragging over cement
like the sound of loose change.

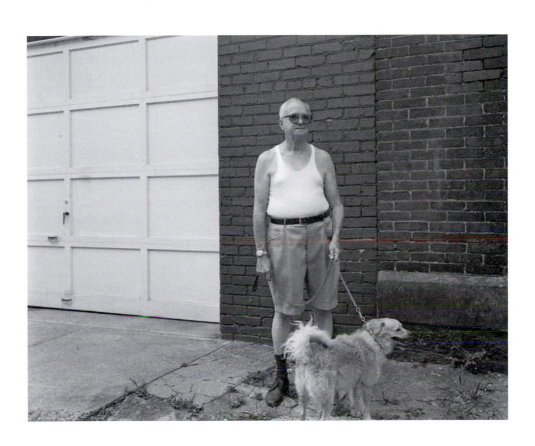

Okay, But Make It Quick

I got ice cream in here
heavy and my arms are chilled.

•

Cinder block vs. aluminum siding,
twelve rounds on belgian block.
Loser chokes on the gutter.

•

Belgian block vs. smooth cement.
A kiss on the cheek vs. a quick squeeze
in the right places.

•

If you take a wrench to the trap
you can fish out all the shit
the sky sends down. Unpaid
bills and expired coupons.
Quick fixes and spinal adjustments.
Holey underwear and holy scriptures.

•

Rings around the elbows like trees.
Around the scarred knees.
Waves in the hair, a nearly calm sea.
Paper not plastic.

•

Too humid to smile. Too suspicious
to stop. Too narrow, one way out.
Door nailed shut. No questions asked

•

Uneven shingles. Teeth of the real
poor. Two taut wires.

•

I had a dream about you. Yeah
you. And if you think I'm gonna
tell. Hey, that almost felt
like a breeze.

•

A watch worn backward
for hands always turned upward
to carry the burden.

•

If you think I'm gonna smile
forget it.

•

Okay, but make it quick.
Yeah, that's what I tell him.

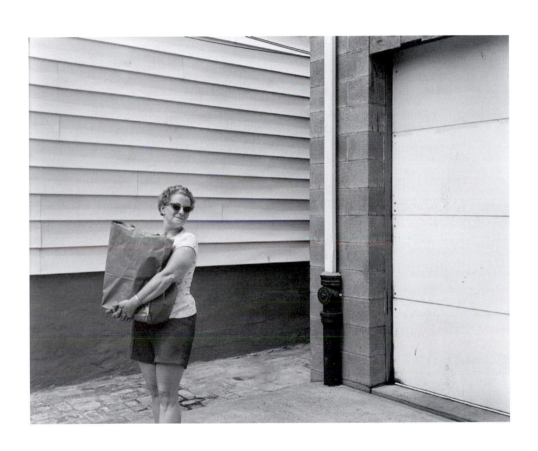

Boy With Comb and Blur

gravel near the tracks
the comb's a new thing—
and dudes and dudettes.

the high wall mish-mash
soot-stained. Closed mill
damage shrugged off.

Just a few pebbles
in his shadow. And
he'll toss those in the river.

Wires sway above him
as if attached to perfect kites.
He wants to be a branch

growing out over the cliff.
You won't see him fading
to a blur, walking away.

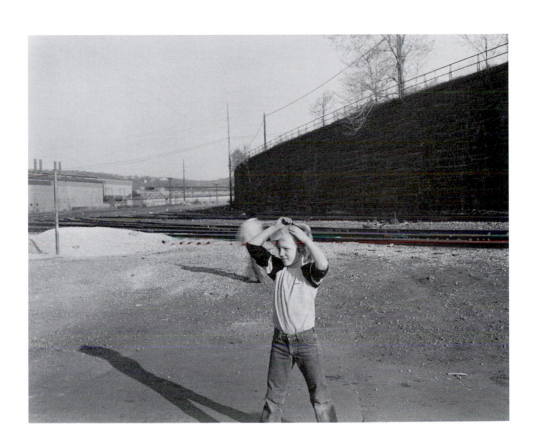

Breeze

The twin packages of the feet
to be unwrapped by love or exhaustion.

The twin packages of movement
and rest. Like some odd spelling rule,

they stay together even when apart.
How many of us have ever been

swept away? Lifted up, and away?
Even the occasions of the white dress

cannot transport us off this earth.
Even the shiny twin packages

even the pointed toes,
even the high heels.

Nothing ever heals completely.
Thus, the breeze. Thus, the sway.

Stillness and Sway

Breeze 66

Ash 68

Surfer Boy 70

First of All 72

Glow 74

Overtaken by Bulldog 76

All Dressed Up and Somewhere to Go 78

Haloes 80

The Feet's Contradictions 82

Fringe 84

No Weeds Need Apply 86

You're the One 88

Waiting / Praying 90

Ash

Too many funerals lately.
The dress shoes hardly getting

any rest, the black polish,
the coarse brush, the soft cloth.

I never asked for this guided tour
of local funeral homes.

Sitting across the street, waiting
to go in. To view. Mumble

a prayer, saying *glad it ain't
me.* Wet comb through the hair

ain't gonna save anybody.
Don't talk to me about smoking.

Nice place for a bench here.
To view. We all hold our

individual number, and they're
all the same number: 1.

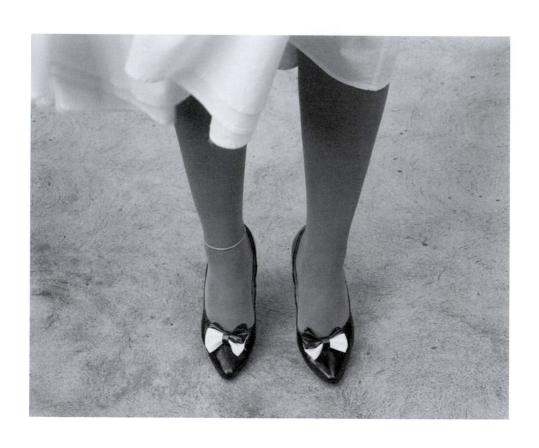

Surfer Boy

I can't do any tricks.
I can ride up and down the street.

Faster than walking.
Faster than talking

to the girls on the corner
the girls on the corner

I want to stop to talk to
I want to keep on going

I think the hair on my legs
is turning darker. My voice

is changing. It won't change
back, I know that much.

Down the street, the waves are coming.
I can't do any tricks.

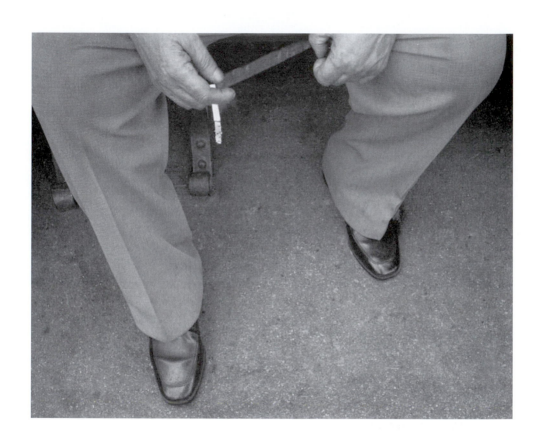

First of All

a bandaid and two scratches
not deep enough to penetrate

the skin. But you can tell
there's nothing fragile

in this picture. Nothing
easily swayed. Nothing

easily relinquished.
And so the thick wrinkled

skirt where a child hung on
for dear life. As if all life

wasn't dear. As if the toes
peeking from their cages

pushing the bars aside
weren't first of all.

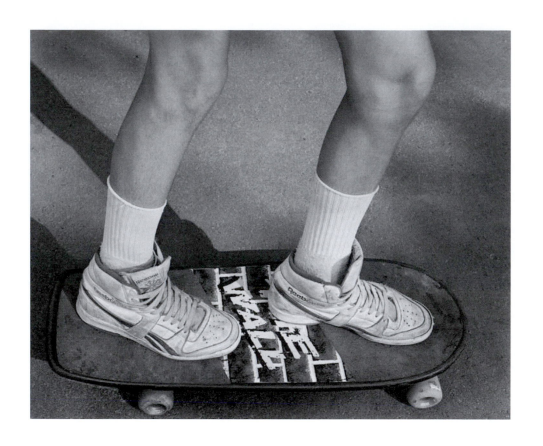

Glow

The scarred knees of the world
imagine their prayers might be

forgiven. White shoes plus
white socks equal minor floating,

brief, illusory, and nearly perfect.
But how long can the shoes

remain white? Two black specks
already, and a road full of grief

waiting to be kicked up, to scuff
its toxic coughs and obscure penance.

Rolled in the socks, the memory
of the last good surprise. For safe-

keeping. One vein of dreams remain. *Life-
blood.* A refusal to pray or ask for more.

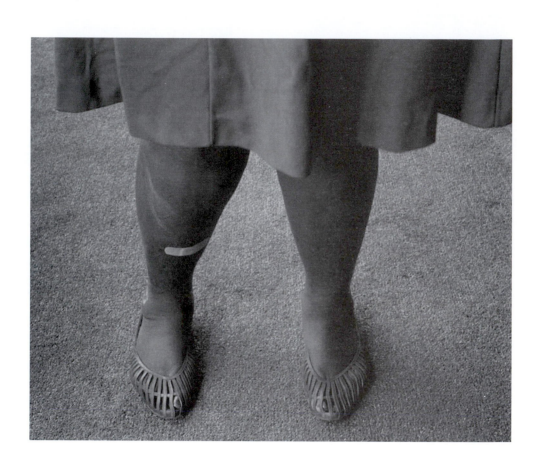

Overtaken by Bulldog

How many times has it happened
to you? Somebody taking your

picture and some cute little dog
plops down and takes over.

Story of my life. My high school
sweetheart was gonna marry me —

bulldog shows up, sits on her feet.
Gonna get the job with the city —

bulldog hops in the van. Put a bid
on a house — bulldog shits on the lawn.

You look for a reason, read the dog
tag, what's it say? *Bull dog.*

As if that explained everything.
What could I do? I got myself a bulldog.

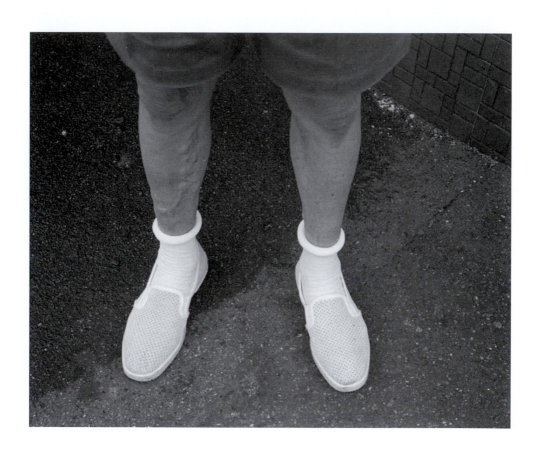

All Dressed Up and Somewhere to Go

on a city bus. He's got his senior's pass chained
to his belt. His loose, relaxed smile turns into a snarl

at a moment's notice. No one knows his name
so they just call him *The Character*. Where exactly

he's going, he ain't telling and nobody's asking,
and he isn't sure himself. He is an expert

on the quality of a stare. They made him give up
his license. Whoever *they* are. Might be a family

that cares about him. But the bus is late again,
and he has a twitch, an itch. A thin, pale leg

inside the enormous blooms of his pant legs.
Some looks exist outside the realm of style.

No matter how much he shines those shoes
he's never going to see his reflection.

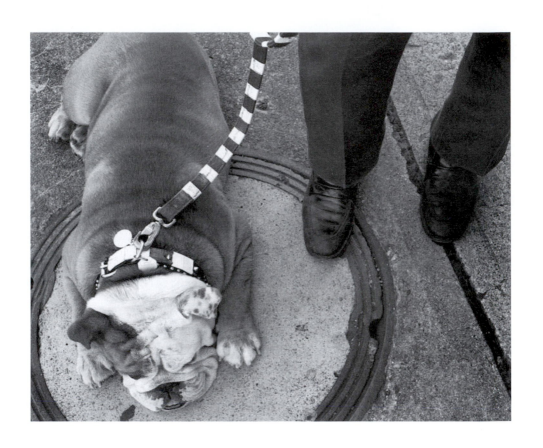

Haloes

Everybody looks for them
around your head

when the feet deserve them
more. Nobody ever got a halo

for standing still. I think
we all have to make our own

haloes. Nobody going to give
them to us. Not on this earth.

If they're too heavy, they turn
into nooses. Haloes are highly

combustible, and come without
instructions or warnings.

If I'm going home with you
I'll be taking them off.

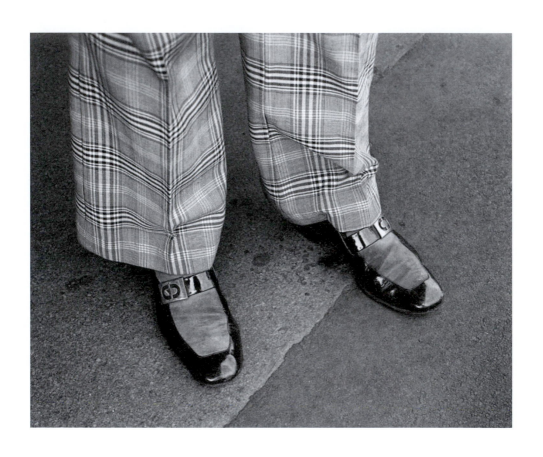

The Feet's Contradictions

So, the one foot says to the other foot....
How many feet does it take to screw in a light bulb?

The straight and narrow. The firm and steady
and unyielding versus the bent, slack

and twisted. Twelve rounds. Title unification
bout. You go your way I'll go mine

within a three-feet radius. Let's beg
the question of the torn knees.

Let's honor the earned grit of both shoes.
They put on a good show. They earned

whatever they got. The judges ruled
it a draw. A no-decision. A no-win

situation. So, one leg sags, and the other
stays rigid. They take turns.

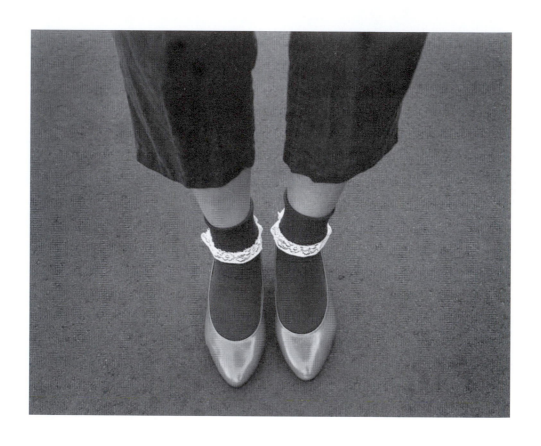

Fringe

April is not the cruelest month.
April enjoys a good smudge.

April is a little shy at first.
April could stand to lose a few pounds.

April could tighten her laces.
April is slippery when wet.

April wears long pants
over its pale skin.

April blows out the candles
and makes the same wish.

April needs a new pair of shoes.
April's middle name is reluctance.

April is deliberately and neatly
fringed. Fringe, with a touch of fray.

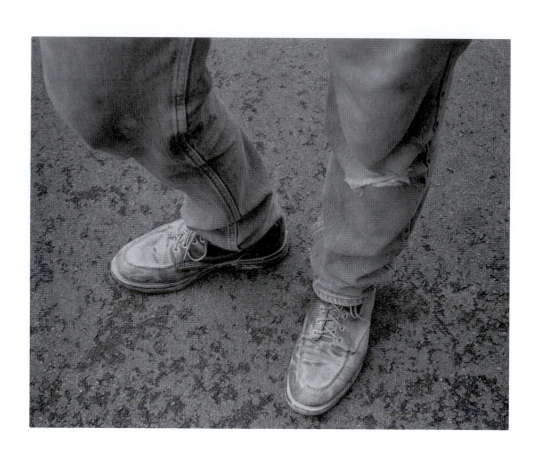

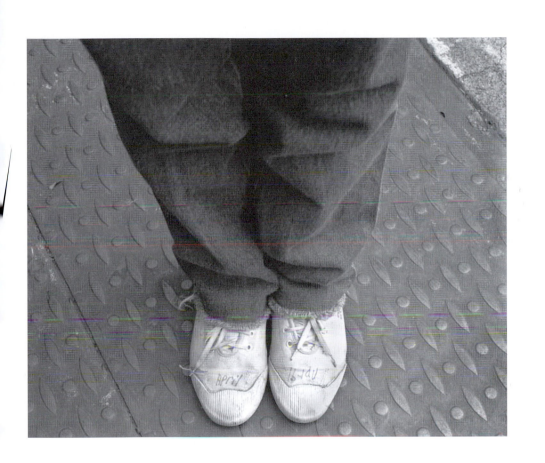

No Weeds Need Apply

I don't joke around. Ask anybody.
I get one pair of shoes and wear

them till they drop. Every day.
The next pair? Exactly the same.

What you see is what you
get. Ask anybody. The socks?

All the same. I don't fish around
for matches. They all match, see?

These are my bricks. I keep them
clean. They got sprays for that.

You crawl in one of those cracks
the poison'd kill you. Step

on my toes, and I'll kill you.
Ask anybody.

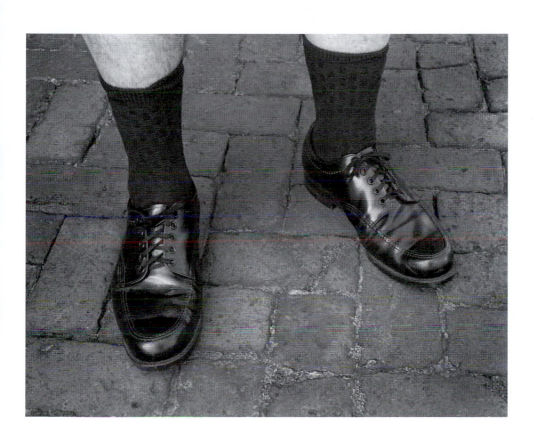

You're the One

giving me all the trouble. Toes
in pantyhose sadly turn away

from each other as if ashamed
of each other's bad habits,

the familiarity of fallen rose petals
retaining their faint scent. Toes

painted, their discomfort on display.
The bright happy look seems

forced, the cheap golden elastic
ties, meant to last only long enough

for the gift to be unwrapped. If we
could just turn away and abandon hope

only to pick it up again at another
location. Or is the word *intimacy*?

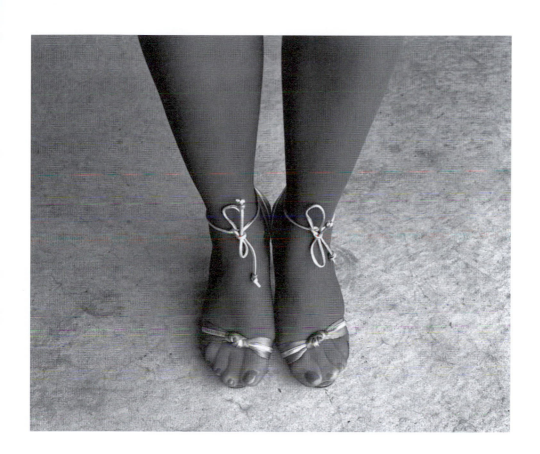

Waiting / Praying

The world comes down to this:
X vs. II

Will we cross, touch, blend
or remain apart?

The shoelace of every shoe
pulled tight, held together

with the knot.
It takes more than thick stockings

to hold us up. We sit. We
rest. We wait

across the parallel lines
of the years. We count

all the lies we have revealed.
All we have covered up.

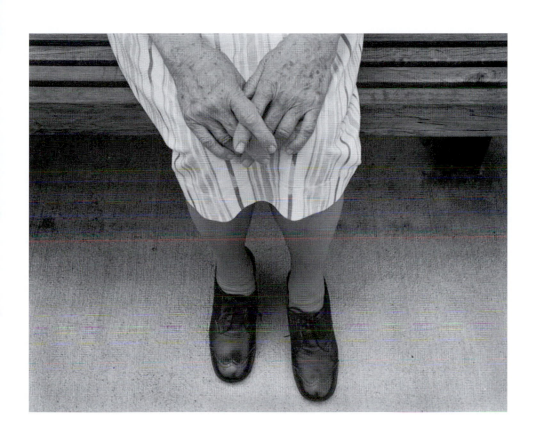

Poet

Jim Daniels has received fellowships from the National Endowment for the Arts and the Pennsylvania Council on the Arts, and his poems have appeared in the Pushcart Prize and Best American Poetry anthologies. He is the Thomas Stockham Baker Professor of English at Carnegie Mellon University.

 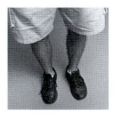 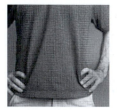

Photographer

Charlee Brodsky, a documentary/fine art photographer and professor of photography at Carnegie Mellon University, describes her work as dealing with social issues and beauty. She exhibits her work nationally and regionally, has been honored with Pennsylvania Arts Fellowships, an Emmy and other awards.

 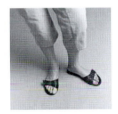 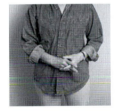

Other Works by the Authors

Jim Daniels

Fiction:
Detroit Tales
No Pets

Poetry:
Show and Tell
Night with Drive-By Shooting Stars
Blue Jesus
Blessing the House
Niagara Falls
M-80
Punching Out
Places/Everyone

Screenplays:
No Pets
Dumpster

Charlee Brodsky

A Town Without Steel,
Envisioning Homestead
Author: Judith Modell
Photographer: Charlee Brodsky

Pittsburgh Revealed;
Photographs Since 1850
Authors: Charlee Brodsky and
Linda Benedict-Jones

Navel-Gazing, the Days and Nights
of a Mother in the Making
Author: Jennifer Matesa
Photographer: Charlee Brodsky

Knowing Stephanie
Words by: Stephanie Byram
Photographer: Charlee Brodsky

Colophon

I've had the good fortune to work on this
project with Jim Daniels and Charlee Brodsky.
The text has been set in Gill Sans Regular,
a modern and slightly quirky font.
The typography is straightforward, without fuss,
much like the poems and photographs.

— Libby Boyarski